DIARY 2008

NRM
NATIONAL RAILWAY MUSEUM

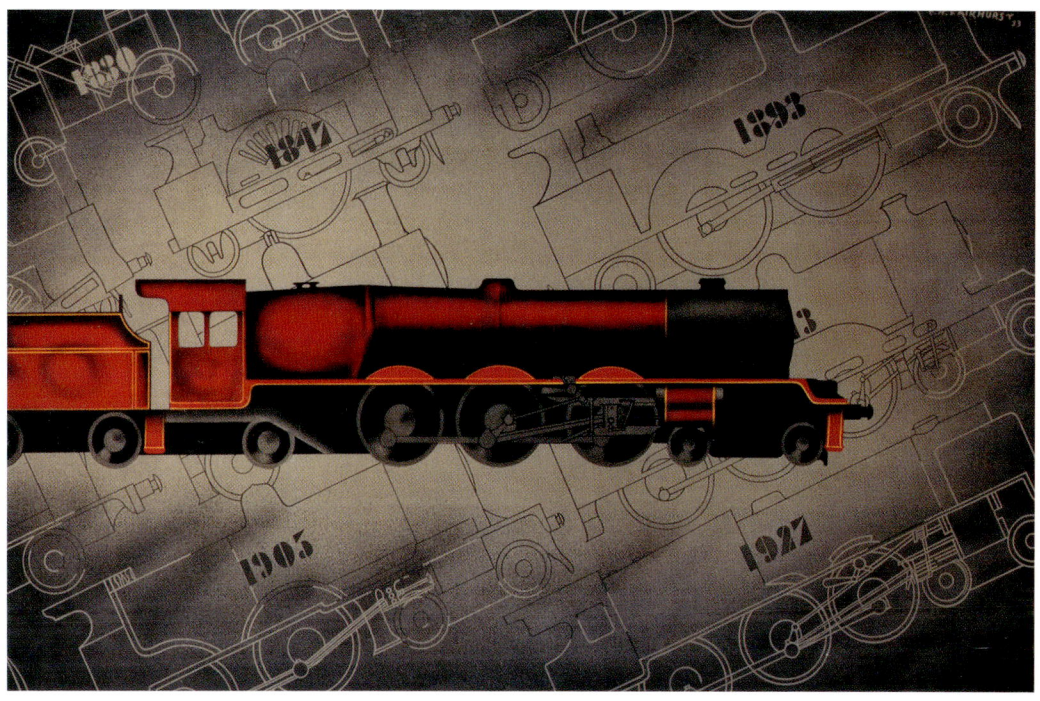

F
FRANCES LINCOLN LIMITED
PUBLISHERS

Frances Lincoln Limited
4 Torriano Mews
Torriano Avenue
London NW5 2RZ
www.franceslincoln.com

National Railway Museum Diary 2008
Copyright © Frances Lincoln Limited 2007

Text and illustrations copyright © National Railway Museum, York/Science & Society Picture Library, London 2007. Science & Society Picture Library represents the collections of the National Railway Museum in York.
www.scienceandsociety.co.uk

Astronomical information reproduced, with permission, from data supplied by HM Nautical Almanac Office copyright © Council for the Central Laboratory of the Research Councils.

All rights reserved. No part of this publication may be reproduced, stored in a retrieval system or transmitted, in any form, or by any means, electronic, mechanical, photocopying, recording or otherwise, without either prior permission in writing from the publishers or a licence permitting restricted copying. In the United Kingdom such licences are issued by the Copyright Licensing Agency, 90 Tottenham Court Road, London W1T 4LP.

British Library cataloguing-in-publication data
A catalogue record for this book is available from the British Library

ISBN 10: 0-7112-2729-2
ISBN 13: 978-0-7112-2729-3

FRONT COVER
A poster produced by the Liverpool and Manchester Railways to promote its centenary celebrations, held in Liverpool between 13 and 20 September 1930. The very latest locomotives were on show, along with miniature railway systems and a pageant of transport every evening. The artist was P. Irwin Brown.

BACK COVER
An LMS poster by Welsh, advertising the railway's service to the Lake District.

TITLE PAGE
Produced in 1933 to promote progress made by the LMS, this poster shows an illustration by E.H. Fairhurst of the Princess Royal steam locomotive superimposed on diagrams of earlier locomotives, including Robert Stephenson's 'Rocket' of 1830. The Princess Royal class of locomotive was introduced in 1933 for use on express passenger services.

OPPOSITE INTRODUCTION
A British Railways poster by Armengol, 1952.

VISITORS' INFORMATION

National Railway Museum
Leeman Road
York, YO26 4XJ

Telephone: 01904 621261
Fax: 01904 611112
e-mail: nrm@nmsi.ac.uk
website: www.nrm.org.uk

24 hour recorded information line: 01904 686286

Admission free

Open
Daily: 10 am to 6 pm
Closed: 24th, 25th & 26th December

Gift Shop
The gift shop is open daily and sells a selection of souvenirs, gifts, videos and books.

Restaurants
The Brief Encounter restaurant in the Station Hall, serving full meals or light snacks, and the Signal Box café in the Great Hall, serving drinks and light snacks, are both open daily.

Disabled visitors
Ramps and lifts provide access to most parts of the museum and wheelchairs may be borrowed from the entrance. There are free disabled parking bays outside the City Entrance. Support dogs are welcome.

Search Engine
Search Engine is the new public archive centre on the NRM's Great Hall Balcony, where anyone visiting the museum is able to drop in and have their questions answered directly from the museum's library and archives without making an appointment. The Information Centre will also house the Railway Community Archive, allowing members of the public to add their family stories to the NRM's archives, and audio-visual booths for access to our oral history and moving image collections. Images of the collections are available to buy as prints from www.ssplprints.com

2008

JANUARY
M T W T F S S
 1 2 3 4 5 6
7 8 9 10 11 12 13
14 15 16 17 18 19 20
21 22 23 24 25 26 27
28 29 30 31

FEBRUARY
M T W T F S S
 1 2 3
4 5 6 7 8 9 10
11 12 13 14 15 16 17
18 19 20 21 22 23 24
25 26 27 28 29

MARCH
M T W T F S S
 1 2
3 4 5 6 7 8 9
10 11 12 13 14 15 16
17 18 19 20 21 22 23
24 25 26 27 28 29 30
31

APRIL
M T W T F S S
 1 2 3 4 5 6
7 8 9 10 11 12 13
14 15 16 17 18 19 20
21 22 23 24 25 26 27
28 29 30

MAY
M T W T F S S
 1 2 3 4
5 6 7 8 9 10 11
12 13 14 15 16 17 18
19 20 21 22 23 24 25
26 27 28 29 30 31

JUNE
M T W T F S S
 1
2 3 4 5 6 7 8
9 10 11 12 13 14 15
16 17 18 19 20 21 22
23 24 25 26 27 28 29
30

JULY
M T W T F S S
 1 2 3 4 5 6
7 8 9 10 11 12 13
14 15 16 17 18 19 20
21 22 23 24 25 26 27
28 29 30 31

AUGUST
M T W T F S S
 1 2 3
4 5 6 7 8 9 10
11 12 13 14 15 16 17
18 19 20 21 22 23 24
25 26 27 28 29 30 31

SEPTEMBER
M T W T F S S
1 2 3 4 5 6 7
8 9 10 11 12 13 14
15 16 17 18 19 20 21
22 23 24 25 26 27 28
29 30

OCTOBER
M T W T F S S
 1 2 3 4 5
6 7 8 9 10 11 12
13 14 15 16 17 18 19
20 21 22 23 24 25 26
27 28 29 30 31

NOVEMBER
M T W T F S S
 1 2
3 4 5 6 7 8 9
10 11 12 13 14 15 16
17 18 19 20 21 22 23
24 25 26 27 28 29 30

DECEMBER
M T W T F S S
1 2 3 4 5 6 7
8 9 10 11 12 13 14
15 16 17 18 19 20 21
22 23 24 25 26 27 28
29 30 31

2009

JANUARY
M T W T F S S
 1 2 3 4
5 6 7 8 9 10 11
12 13 14 15 16 17 18
19 20 21 22 23 24 25
26 27 28 29 30 31

FEBRUARY
M T W T F S S
 1
2 3 4 5 6 7 8
9 10 11 12 13 14 15
16 17 18 19 20 21 22
23 24 25 26 27 28

MARCH
M T W T F S S
 1
2 3 4 5 6 7 8
9 10 11 12 13 14 15
16 17 18 19 20 21 22
23 24 25 26 27 28 29
30 31

APRIL
M T W T F S S
 1 2 3 4 5
6 7 8 9 10 11 12
13 14 15 16 17 18 19
20 21 22 23 24 25 26
27 28 29 30

MAY
M T W T F S S
 1 2 3
4 5 6 7 8 9 10
11 12 13 14 15 16 17
18 19 20 21 22 23 24
25 26 27 28 29 30 31

JUNE
M T W T F S S
1 2 3 4 5 6 7
8 9 10 11 12 13 14
15 16 17 18 19 20 21
22 23 24 25 26 27 28
29 30

JULY
M T W T F S S
 1 2 3 4 5
6 7 8 9 10 11 12
13 14 15 16 17 18 19
20 21 22 23 24 25 26
27 28 29 30 31

AUGUST
M T W T F S S
 1 2
3 4 5 6 7 8 9
10 11 12 13 14 15 16
17 18 19 20 21 22 23
24 25 26 27 28 29 30
31

SEPTEMBER
M T W T F S S
 1 2 3 4 5 6
7 8 9 10 11 12 13
14 15 16 17 18 19 20
21 22 23 24 25 26 27
28 29 30

OCTOBER
M T W T F S S
 1 2 3 4
5 6 7 8 9 10 11
12 13 14 15 16 17 18
19 20 21 22 23 24 25
26 27 28 29 30 31

NOVEMBER
M T W T F S S
 1
2 3 4 5 6 7 8
9 10 11 12 13 14 15
16 17 18 19 20 21 22
23 24 25 26 27 28 29
30

DECEMBER
M T W T F S S
 1 2 3 4 5 6
7 8 9 10 11 12 13
14 15 16 17 18 19 20
21 22 23 24 25 26 27
28 29 30 31

INTRODUCTION

The period between 1923 and 1947 was the heyday of the railway poster. These were the years of the so-called 'Big Four' companies – the Great Western Railway (GWR), the Southern Railway (SR), the London Midland and Scottish Railway (LMS) and the London and North Eastern Railway (LNER). Competing for passengers, the companies each produced colourful and dramatic posters featuring destinations covered by their networks. The posters relied on good design and a strong image for their appeal, and developed into a distinctive style of poster advertising.

With the creation of the British Transport Commission in 1948, the 'Big Four' companies passed into public ownership. Rail nationalization brought optimism and hope to many and this was reflected in the British Railways posters of the 1950s and 1960s, which recapture much of the fun of earlier years.

Included in this diary are a selection of posters from the 'Big Four' and British Railways. They are all from the collection of 14,000 historic railway posters in the National Railway Museum in York. The museum is the largest of its kind in the world, home to a wide range of railway icons and literally millions of artefacts, from Mallard – the world's fastest steam engine – to a lock of Robert Stephenson's hair, and a vast collection of 103 locomotives and engines.

DECEMBER & JANUARY

WEEK 1

31 MONDAY
LAST QUARTER
New Year's Eve

1 TUESDAY
New Year's Day
Holiday, UK, Republic of Ireland, Canada, USA,
Australia and New Zealand

2 WEDNESDAY
Holiday, Scotland and New Zealand

3 THURSDAY

4 FRIDAY

5 SATURDAY

6 SUNDAY
Epiphany

An LNER poster by Doris Zinkeisen, 1937.

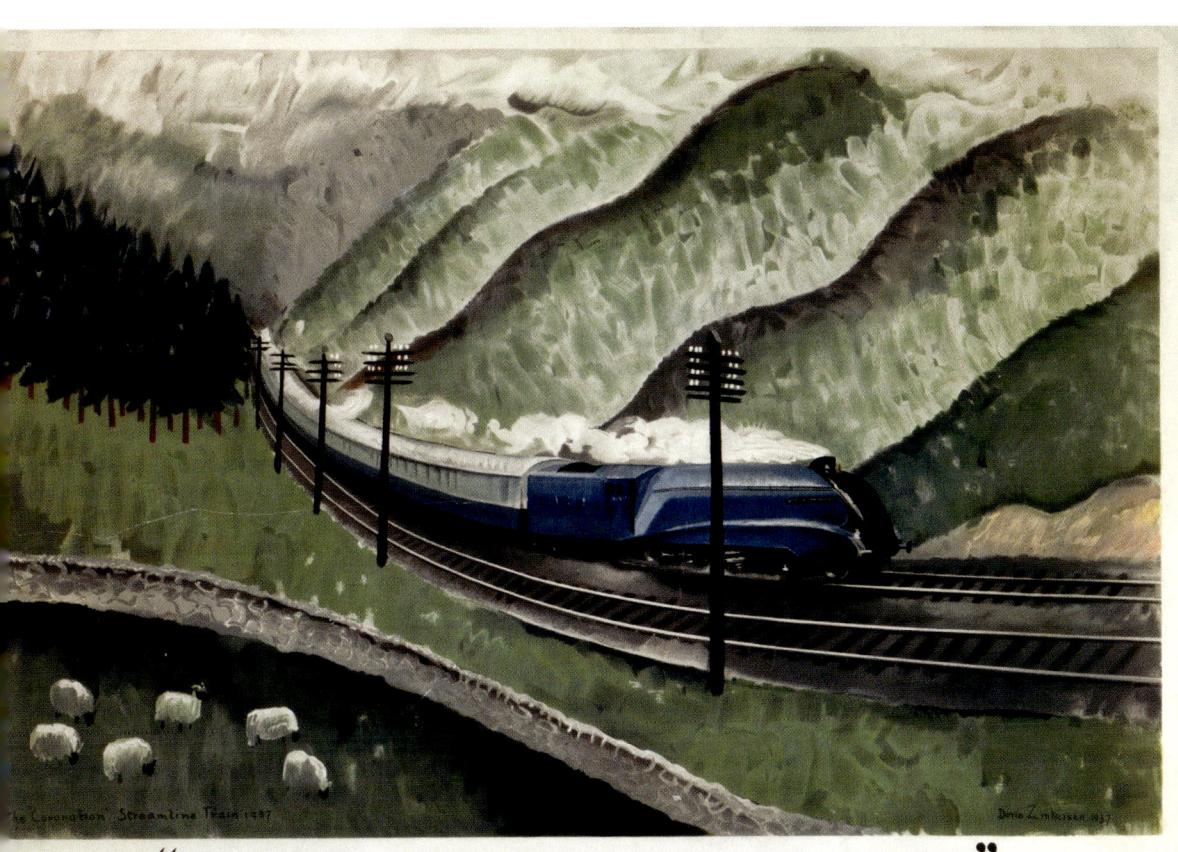

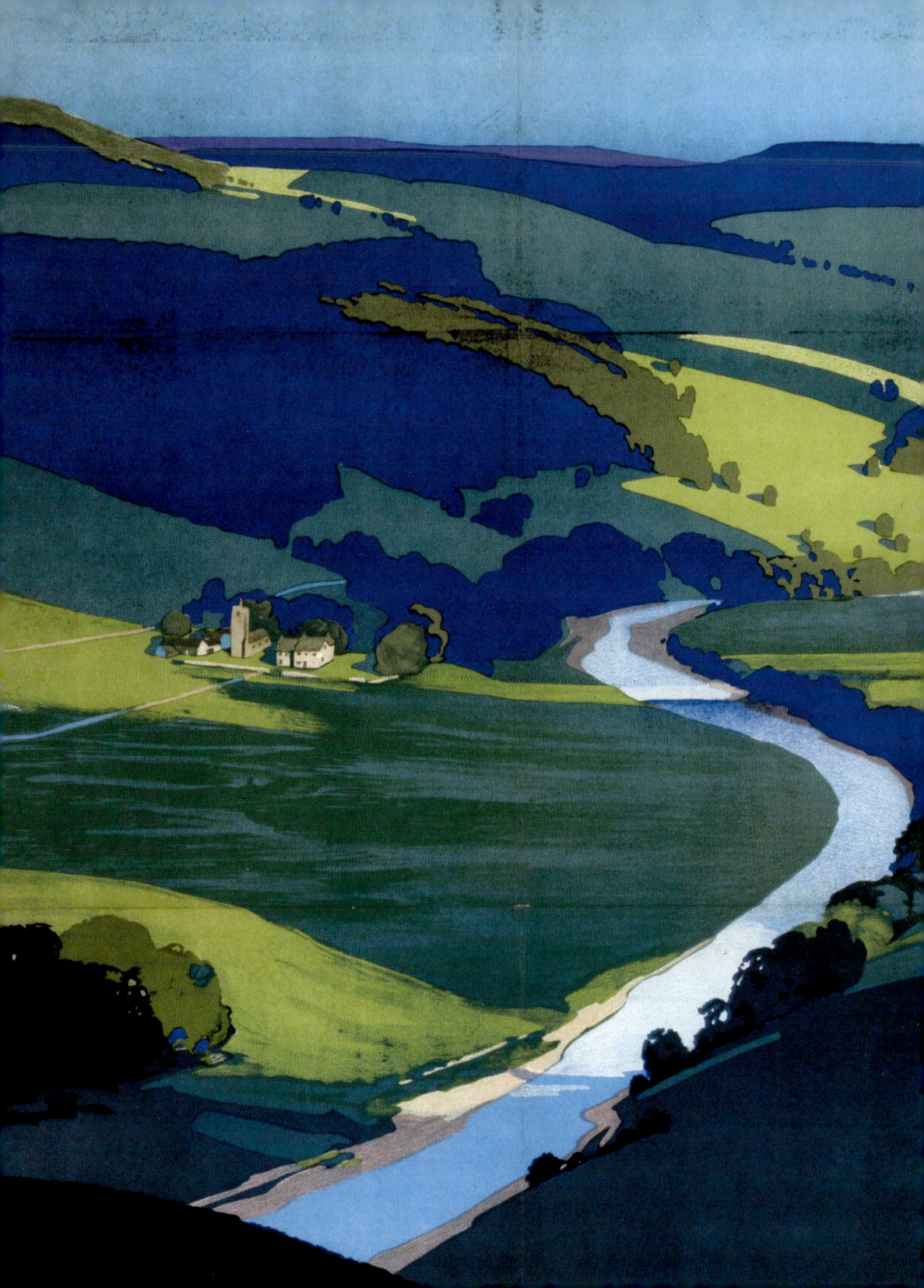

JANUARY

WEEK 2

7 MONDAY

8 TUESDAY
NEW MOON

9 WEDNESDAY

10 THURSDAY
Islamic New Year (subject to sighting of the moon)

11 FRIDAY

12 SATURDAY

13 SUNDAY

An LNER poster by Austin Cooper, promoting rail travel to the Yorkshire Dales. Cooper was a Canadian who studied art in Cardiff and Arbroath. He began his career as a commercial artist in Montreal but returned to London in 1922 and designed posters for LNER, Indian State Railways and London Transport. He held his first show at the London Gallery in 1948.

JANUARY

WEEK 3

14 MONDAY

15 TUESDAY
FIRST QUARTER

16 WEDNESDAY

17 THURSDAY

18 FRIDAY

19 SATURDAY

20 SUNDAY

A GWR poster by Louis Burleigh Bruhl.

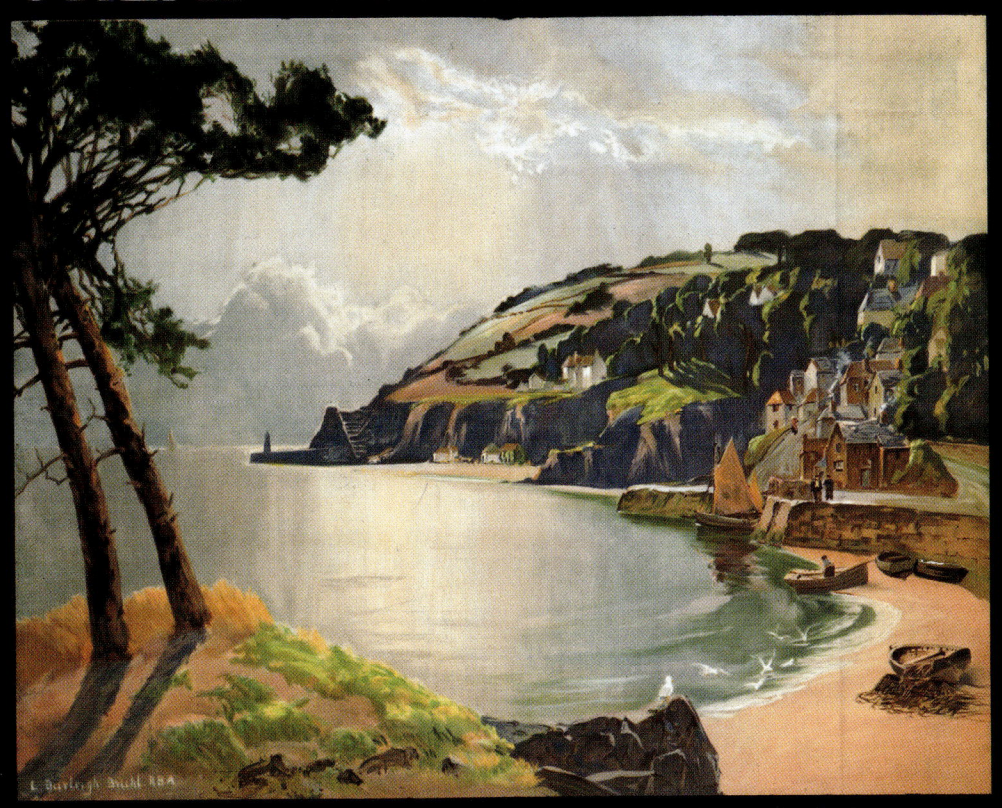

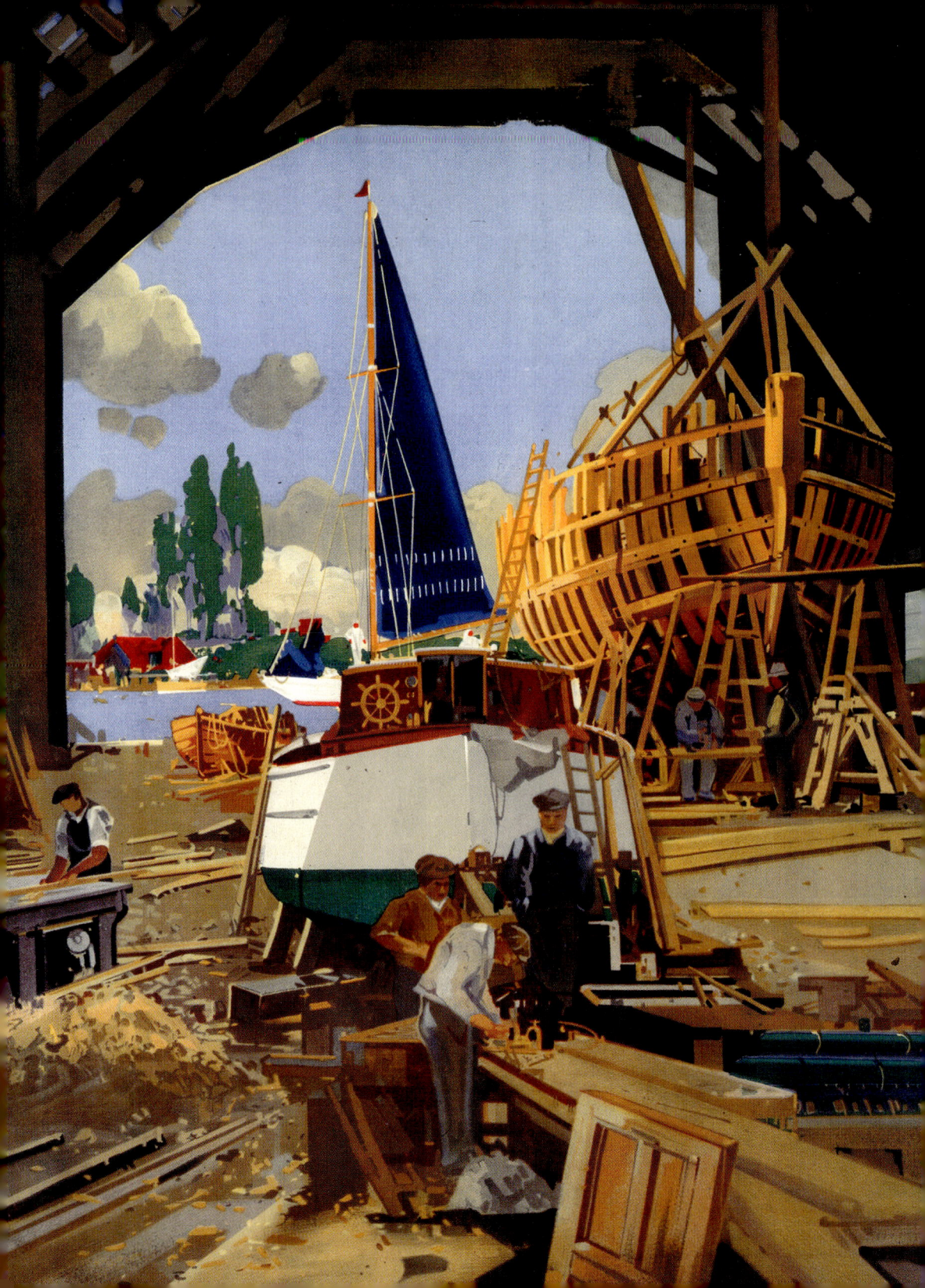

JANUARY

WEEK 4

21 MONDAY
Holiday, USA (Martin Luther King's birthday)

22 TUESDAY
FULL MOON

23 WEDNESDAY

24 THURSDAY

25 FRIDAY

26 SATURDAY

27 SUNDAY

One of an LNER poster series called 'East Coast Types' (see weeks 5, 25, 34, 35 and 41), which illustrated different types of people frequently met on the beaches of the east coast. This one shows boat builders. The artist was Frank Henry Mason, who painted marine and coastal subjects and was involved in engineering and shipbuilding, as well as designing posters for several railway companies.

JANUARY & FEBRUARY

WEEK 5

28 MONDAY
Holiday, Australia (Australia Day)

29 TUESDAY

30 WEDNESDAY
LAST QUARTER

31 THURSDAY

1 FRIDAY

2 SATURDAY

3 SUNDAY

Another poster in LNER's series 'East Coast Types' (see weeks 4, 25, 34, 35 and 41), by Frank Newbould, who studied at Bradford College of Art, joined the War Office in 1942 and also designed posters for GWR, the Orient Line and Belgian Railways.

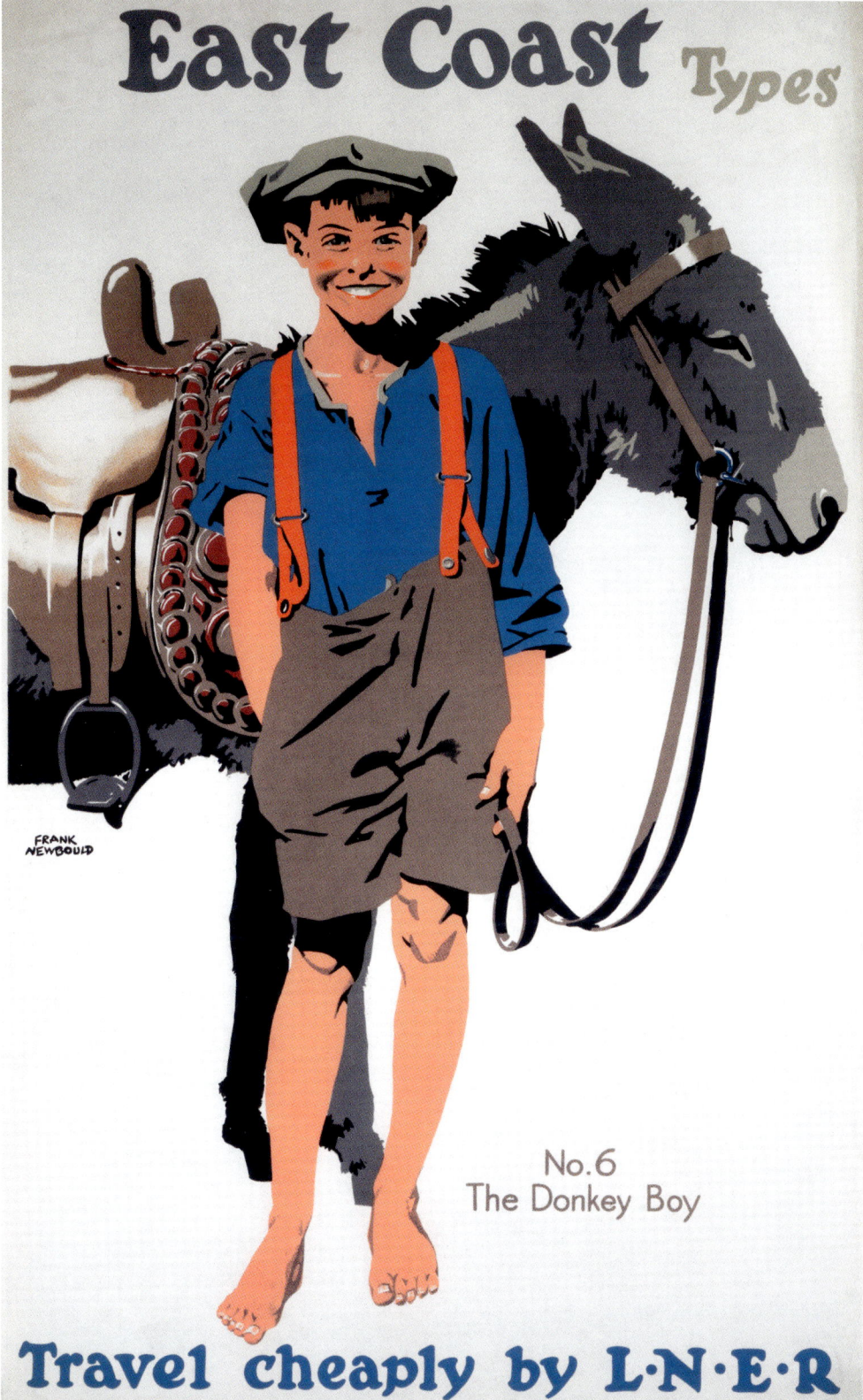

LONDON PRIDE

FEBRUARY

WEEK 6

4 MONDAY

5 TUESDAY
Shrove Tuesday

6 WEDNESDAY
Ash Wednesday
Holiday, New Zealand (Waitangi Day)

7 THURSDAY
NEW MOON
Chinese New Year

8 FRIDAY

9 SATURDAY

10 SUNDAY

GWR produced this poster in 1946, just after the Second World War, to promote rail travel to London. As in his other posters of London, the artist, Frank Henry Mason, does not depict the damage inflicted by the Blitz but instead shows life going on as normal.

FEBRUARY

WEEK 7

11 MONDAY

12 TUESDAY
Holiday, USA (Lincoln's birthday)

13 WEDNESDAY

14 THURSDAY
FIRST QUARTER
St Valentine's Day

15 FRIDAY

16 SATURDAY

17 SUNDAY

A wartime British Railways poster by Leslie Carr.

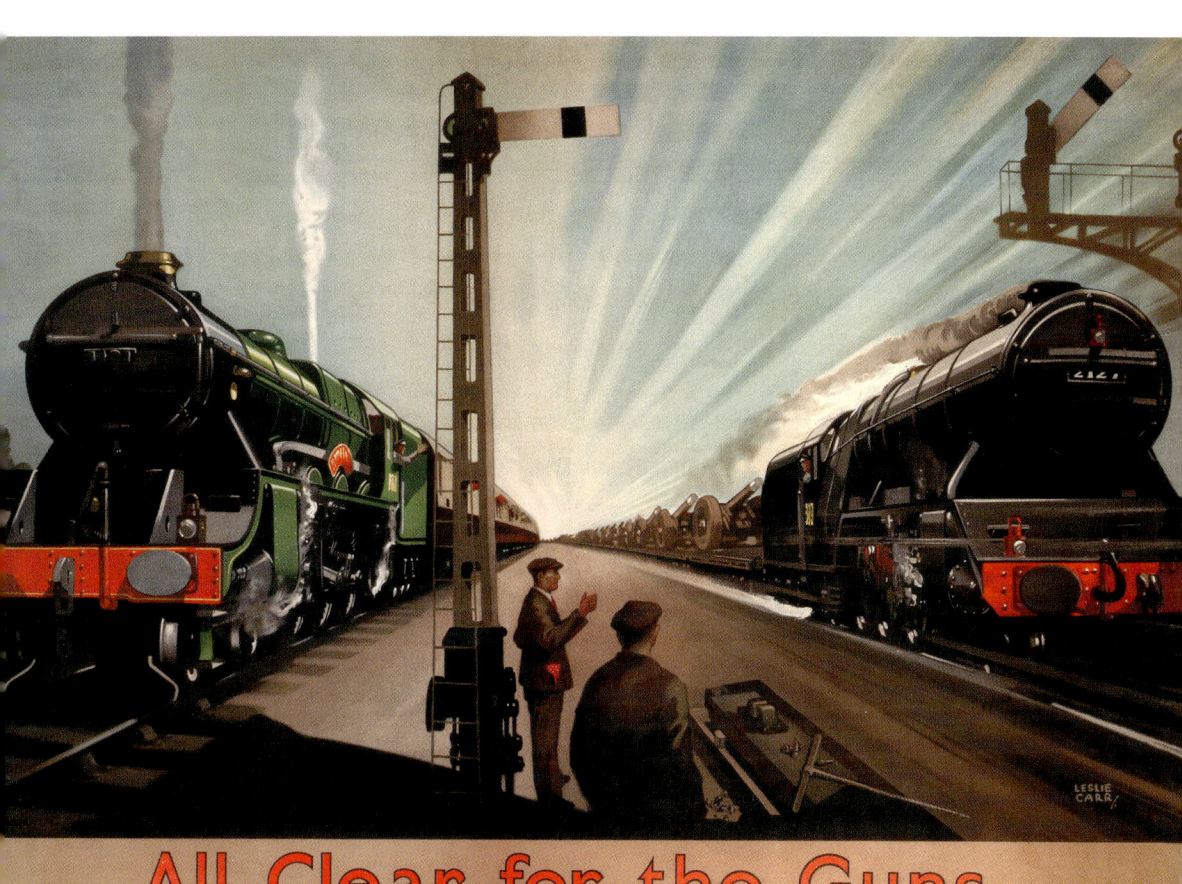

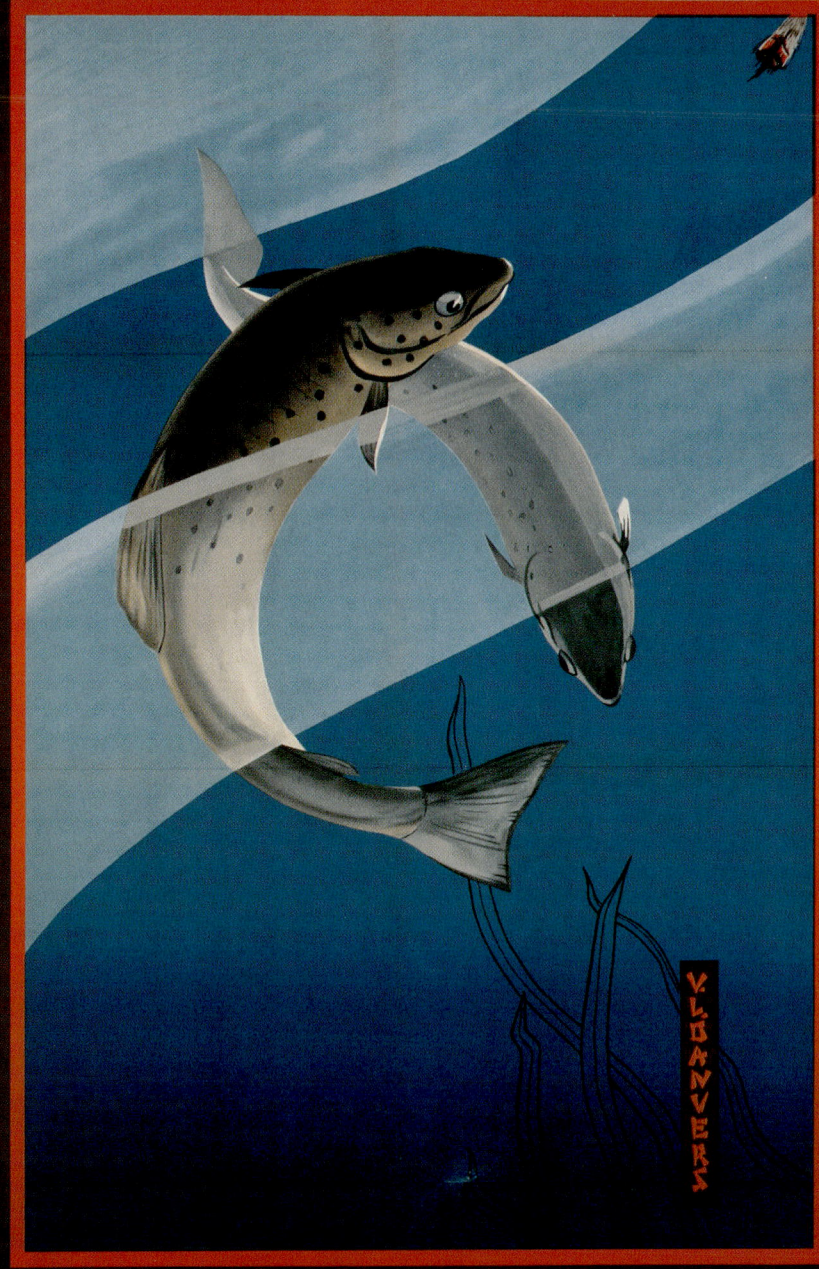

FEBRUARY

WEEK 8

18 MONDAY
Holiday, USA (Washington's birthday)

19 TUESDAY

20 WEDNESDAY

21 THURSDAY
FULL MOON

22 FRIDAY

23 SATURDAY

24 SUNDAY

An LNER poster, c.1925. The artist, Verney L. Danvers, ran a school of commercial art and was commissioned by fashion and interior design companies. He also designed posters for SR and London Transport.

FEBRUARY & MARCH

WEEK 9

25 MONDAY

26 TUESDAY

27 WEDNESDAY

28 THURSDAY

29 FRIDAY
LAST QUARTER

1 SATURDAY
St David's Day

2 SUNDAY
Mothering Sunday, UK

A GWR poster by Graham Petrie.

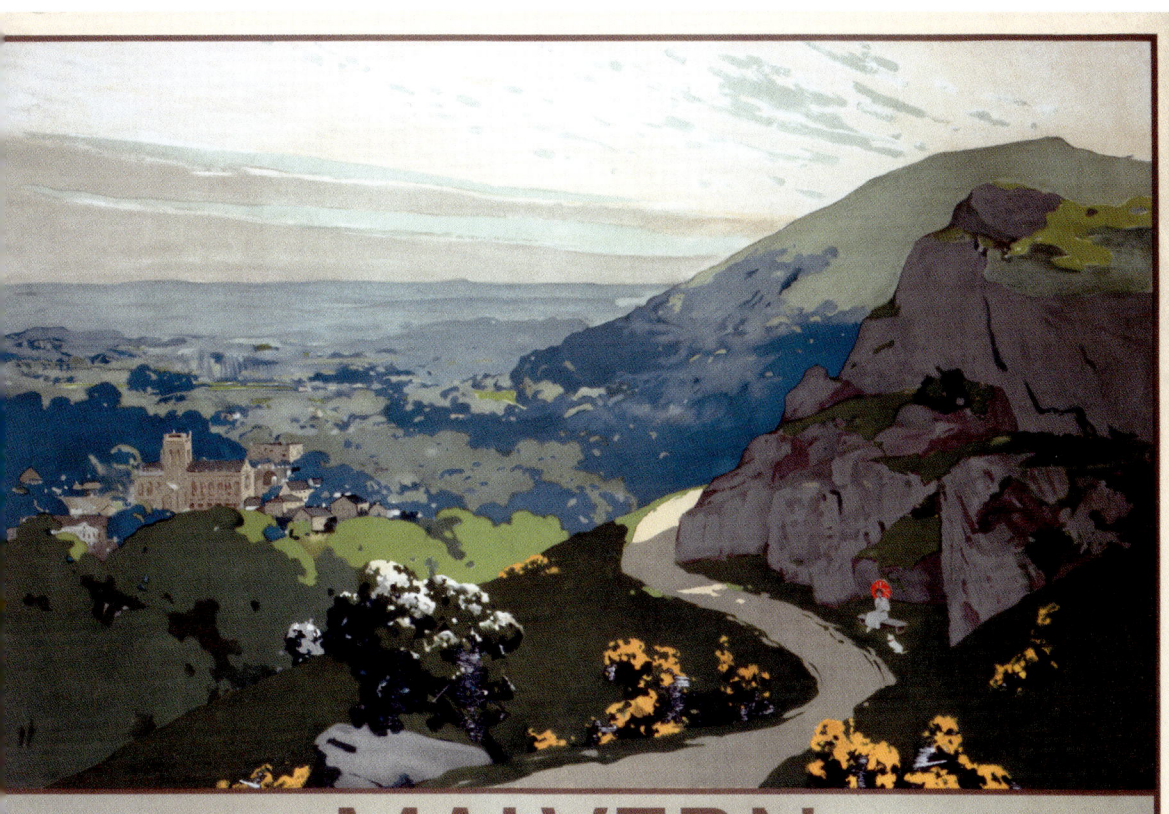

MARCH

WEEK 10

3 MONDAY

4 TUESDAY

5 WEDNESDAY

6 THURSDAY

7 FRIDAY
NEW MOON

8 SATURDAY

9 SUNDAY

An LNER poster by Frank Henry Mason.

MARCH

WEEK 11

10 MONDAY
Commonwealth Day

11 TUESDAY

12 WEDNESDAY

13 THURSDAY

14 FRIDAY
FIRST QUARTER

15 SATURDAY

16 SUNDAY
Palm Sunday

A LMS poster by Richard Jack, 1924.

BRITISH INDUSTRIES
LMS
STEEL
BY RICHARD JACK, R.A.

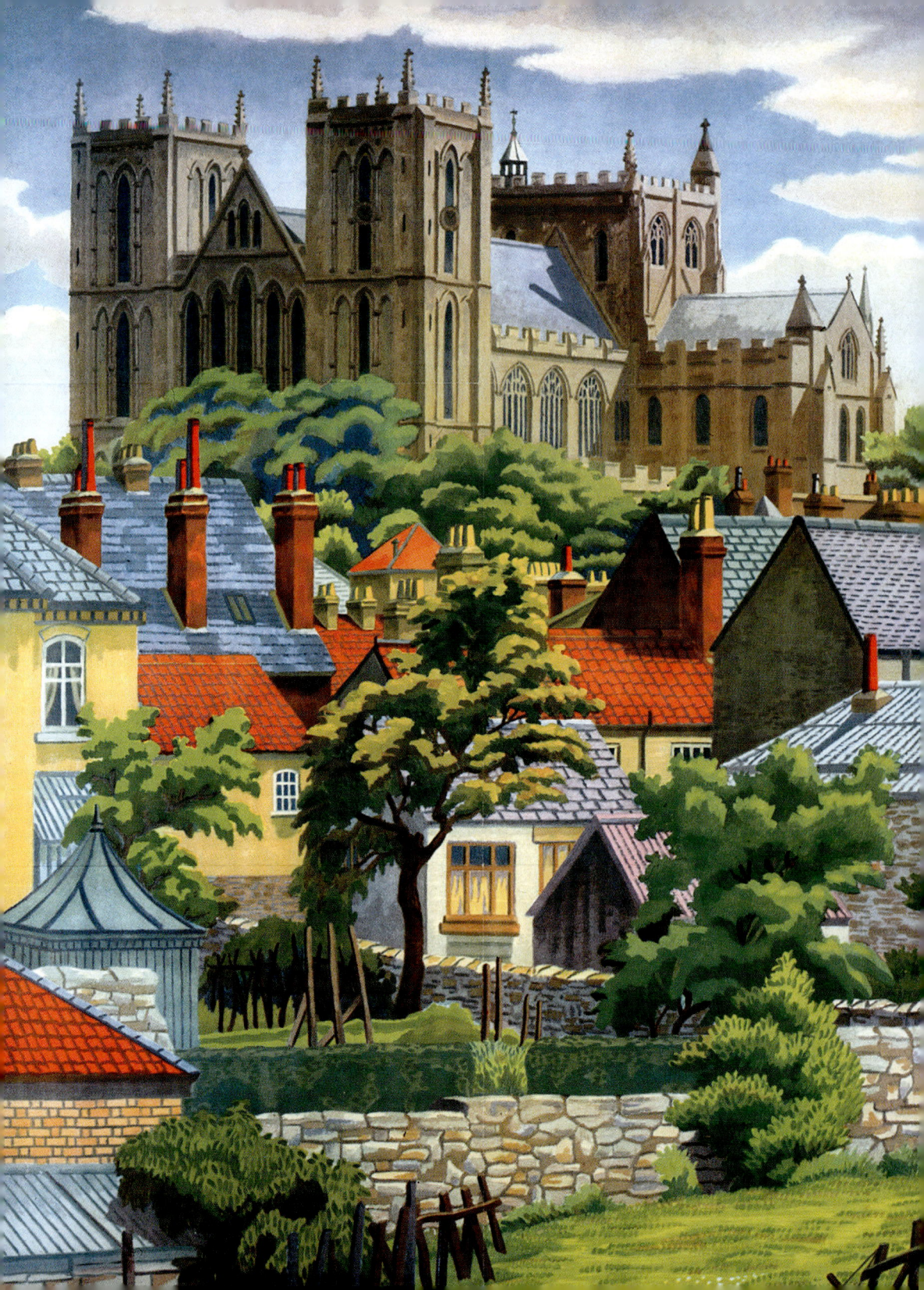

MARCH

WEEK 12

17 MONDAY
St Patrick's Day
Holiday, Northern Ireland and Republic of Ireland

18 TUESDAY

19 WEDNESDAY

20 THURSDAY
Maundy Thursday
Vernal Equinox

21 FRIDAY
FULL MOON
Good Friday
Holiday, UK, Canada, USA, Australia and New Zealand

22 SATURDAY

23 SUNDAY
Easter Sunday

An LNER poster by Charles Ginner, produced to promote rail travel to Ripon in Yorkshire, c.1930.

MARCH

WEEK 13

24 MONDAY
Easter Monday
Holiday, UK (exc. Scotland), Republic of Ireland,
Canada, Australia and New Zealand

25 TUESDAY

26 WEDNESDAY

27 THURSDAY

28 FRIDAY

29 SATURDAY
LAST QUARTER

30 SUNDAY
British Summertime begins

A poster by Keith Henderson, produced jointly by LNER and LMS.

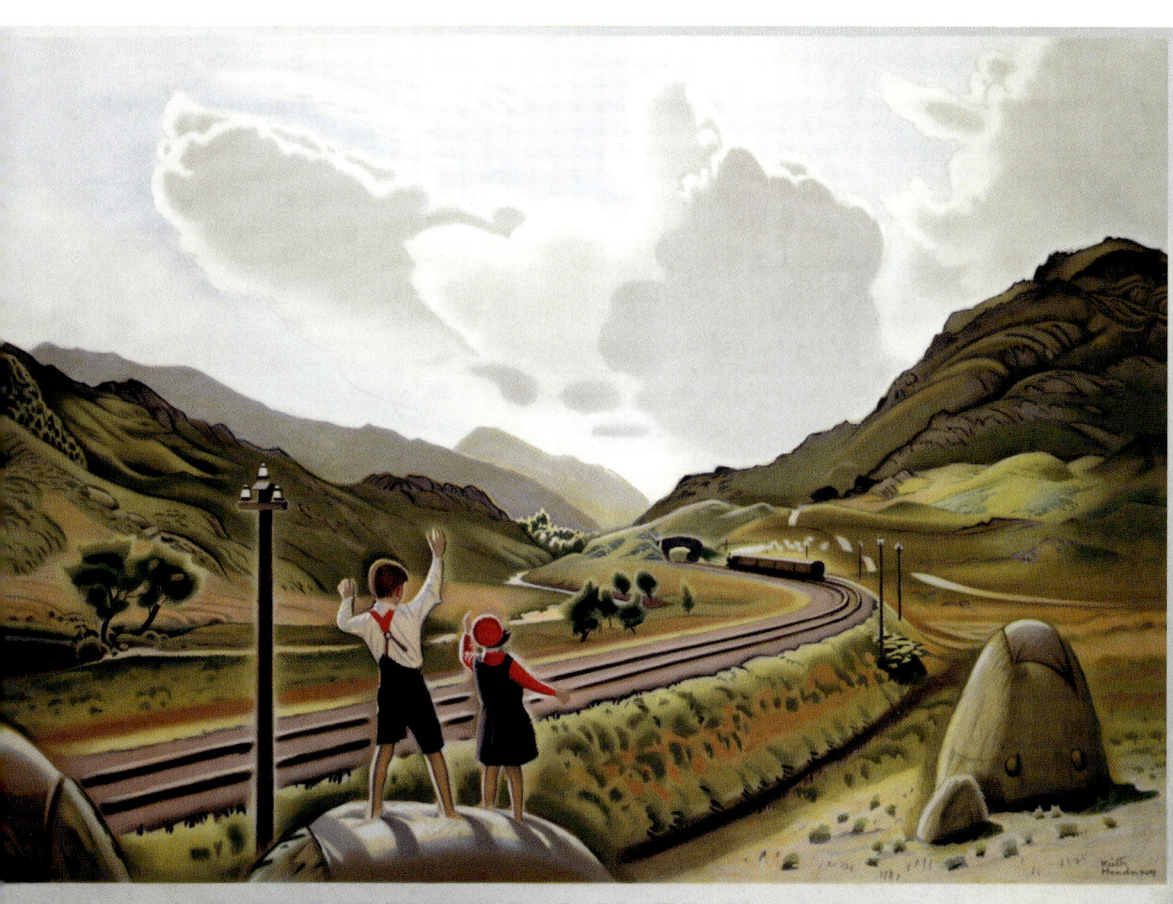

SALTBURN·BY·THE·SEA

Illustrated Booklet free from the Clerk to the Urban District Council Saltburn or any L·N·E·R Enquiry Office.

MARCH & APRIL

WEEK 14

31 MONDAY

1 TUESDAY

2 WEDNESDAY

3 THURSDAY

4 FRIDAY

5 SATURDAY

6 SUNDAY
NEW MOON

An LNER poster by Frank Henry Mason, showing a seaside resort in Cleveland, c.1920.

APRIL

WEEK 15

7 MONDAY

8 TUESDAY

9 WEDNESDAY

10 THURSDAY

11 FRIDAY

12 SATURDAY
FIRST QUARTER

13 SUNDAY

An SR poster by Rojan, 1937.

The ROYAL ALBERT BRIDGE, SALTASH
Brunel's famous link between Glorious Devon and The Cornish Riviera

GWR

APRIL

WEEK 16

14 MONDAY

15 TUESDAY

16 WEDNESDAY

17 THURSDAY

18 FRIDAY

19 SATURDAY

20 SUNDAY
FULL MOON
Passover (Pesach), First Day

A GWR poster of 1945, showing the Royal Albert Bridge over the River Tamar, which links Devon and Cornwall, the destinations being promoted. The artwork is from a watercolour by Anton Abraham van Anrooy, a Dutchman who painted portraits and interiors as well as designing posters for LNER and GWR.

APRIL

WEEK 17

21 MONDAY
Birthday of Queen Elizabeth II

22 TUESDAY

23 WEDNESDAY
St George's Day

24 THURSDAY

25 FRIDAY
Holiday, Australia and New Zealand (Anzac Day)

26 SATURDAY
Passover (Pesach), Seventh Day

27 SUNDAY
Passover (Pesach), Eighth Day

With the slogan 'Norwich – It's Quicker by Rail', this poster by Frank Henry Mason promoted LNER's rail services to the city in the 1930s.

CADER IDRIS & THE AFON MAWDDACH

GWR **WALES** GWR

APRIL & MAY

WEEK 18

28 MONDAY
LAST QUARTER

29 TUESDAY

30 WEDNESDAY

1 THURSDAY
Ascension Day

2 FRIDAY

3 SATURDAY

4 SUNDAY

A GWR poster of 1937 by Sir Herbert Alker Tripp, who painted in his spare time (he had a successful career with New Scotland Yard) and in his retirement, and also designed posters for SR.

MAY

WEEK 19

5 MONDAY
NEW MOON
Early May Bank Holiday, UK and Republic of Ireland

6 TUESDAY

7 WEDNESDAY

8 THURSDAY

9 FRIDAY

10 SATURDAY

11 SUNDAY
Whit Sunday (Pentecost)
Mother's Day, Canada, USA, Australia and New Zealand

With the slogan 'Knaresborough: It's Quicker by Rail', this LNER poster promoted rail travel to the Yorkshire town in 1928. As well as producing posters for LNER, Henry George Gawthorn, the artist, wrote several books on poster design and publicity. His posters often include a self-portrait, complete with pince-nez and a panama hat.

SCARBOROUGH
1930 BOOKLET FREE FROM TOWN HALL OR ANY L·N·E·R AGENCY

MAY

WEEK 20

12 MONDAY
FIRST QUARTER

13 TUESDAY

14 WEDNESDAY

15 THURSDAY

16 FRIDAY

17 SATURDAY

18 SUNDAY
Trinity Sunday

An LNER poster by Frank Newbould, 1930.

MAY

WEEK 21

19 MONDAY
Holiday, Canada (Victoria Day)

20 TUESDAY
FULL MOON

21 WEDNESDAY

22 THURSDAY
Corpus Christi

23 FRIDAY

24 SATURDAY

25 SUNDAY

An LMS poster of the 1930s by Norman Wilkinson. A famous marine painter, Wilkinson also designed posters for the London & North Western Railway, the London & Midlands Railway (LMR) and the SR, and organized the Royal Academy series of posters for the LMR in 1924.

SILLOTH
ON THE SOLWAY

FIRST CLASS GOLF & TENNIS

Illustrated booklet from any L·N·E·R Enquiry Office or from the Advertising Dept., District Council, Silloth.

MAY & JUNE

WEEK 22

26 MONDAY
Spring Bank Holiday, UK
Holiday, USA (Memorial Day)

27 TUESDAY

28 WEDNESDAY
LAST QUARTER

29 THURSDAY

30 FRIDAY

31 SATURDAY

1 SUNDAY

This LNER poster by Leslie Carr promoted rail travel to Silloth on the Solway Firth, Cumbria.

JUNE

WEEK 23

2 MONDAY
Holiday, Republic of Ireland
Holiday, New Zealand (The Queen's birthday)

3 TUESDAY
NEW MOON

4 WEDNESDAY

5 THURSDAY

6 FRIDAY

7 SATURDAY

8 SUNDAY

A poster by Norman Wilkinson, produced jointly by LMS and LNER, c.1935.

BY NORMAN WILKINSON. R.I.

LMS **LANARKSHIRE STEEL WORKS** **LNER**

HASTINGS
AND ST. LEONARDS

All enquiries to PR 300
Information Bureau, Hastings

Fast and Frequent Ser
of Trains from London

BRITISH RAILWAYS

JUNE

WEEK 24

9 MONDAY
Jewish Feast of Weeks (Shavuot)

10 TUESDAY
FIRST QUARTER

11 WEDNESDAY

12 THURSDAY

13 FRIDAY

14 SATURDAY
The Queen's official birthday (subject to confirmation)

15 SUNDAY
Fathers Day, UK, Canada and USA

A British Railways (Southern Region) poster by F.W. Wentworth-Shields, 1959.

JUNE

WEEK 25

16 MONDAY

17 TUESDAY

18 WEDNESDAY
FULL MOON

19 THURSDAY

20 FRIDAY
Summer Solstice

21 SATURDAY

22 SUNDAY

Another of the LNER series called 'East Coast Types' (see weeks 4, 5, 34, 35 and 41), by Frank Newbould, 1931.

NORFOLK BROADS

BRITISH RAILWAYS

There is an excellent train service to the larger centres in Norfolk from many areas
In the summer months travel mid-week if you can — it may be cheaper

JUNE

WEEK 26

23 MONDAY

24 TUESDAY

25 WEDNESDAY

26 THURSDAY
LAST QUARTER

27 FRIDAY

28 SATURDAY

29 SUNDAY

A British Railways (Eastern Region) poster by Raymond Piper, 1963.

JUNE & JULY

WEEK 27

30 MONDAY

1 TUESDAY
Holiday, Canada (Canada Day)

2 WEDNESDAY

3 THURSDAY
NEW MOON

4 FRIDAY
Holiday, USA (Independence Day)

5 SATURDAY

6 SUNDAY

An LNER poster by Leonard Cusden, promoting train services to Redcar, Yorkshire in 1936–7.

REDCAR
IT'S QUICKER BY RAIL
EW ILLUSTRATED GUIDE FREE FROM TOWN CLERK OR ANY L·N·E·R OFFICE OR AGENCY

JULY

WEEK 28

7 MONDAY

8 TUESDAY

9 WEDNESDAY

10 THURSDAY
FIRST QUARTER

11 FRIDAY

12 SATURDAY

13 SUNDAY

Tenby in Pembrokeshire paid 75 per cent of the cost of producing this GWR poster to promote its North Beach in 1946. The artist was Ronald Lampitt.

JULY

WEEK 29

14 MONDAY
Holiday, Northern Ireland (Battle of the Boyne)

15 TUESDAY
St Swithin's Day

16 WEDNESDAY

17 THURSDAY

18 FRIDAY
FULL MOON

19 SATURDAY

20 SUNDAY

An SR poster by Edmond Vaughan, promoting the railway's electric train services, 1932.

THE YORKSHIRE COAST

ILLUSTRATED BOOKLETS FREE FROM PASSENGER MANAGER LIVERPOOL STREET STATION E.C.2; YORK WAVERLEY STATION EDINBURGH: TRAFFIC SUPERINTENDENT L·N·E·R ABERDEEN: OR ANY L·N·E·R AGENCY

JULY

WEEK 30

21 MONDAY

22 TUESDAY

23 WEDNESDAY

24 THURSDAY

25 FRIDAY
LAST QUARTER

26 SATURDAY

27 SUNDAY

An LNER poster by Andrew Johnson.

JULY & AUGUST

WEEK 31

28 MONDAY

29 TUESDAY

30 WEDNESDAY

31 THURSDAY

1 FRIDAY
NEW MOON

2 SATURDAY

3 SUNDAY

Norman Wilkinson's depiction of the Giant's Causeway in North Antrim promoted 'Ireland for Holidays' for LMS.

AUGUST

WEEK 32

4 MONDAY
Summer Bank Holiday, Scotland and Republic of Ireland

5 TUESDAY

6 WEDNESDAY

7 THURSDAY

8 FRIDAY
FIRST QUARTER

9 SATURDAY

10 SUNDAY

An LMS poster by Jackson Burton, c.1930.

AUGUST

WEEK 33

11 MONDAY

12 TUESDAY

13 WEDNESDAY

14 THURSDAY

15 FRIDAY

16 SATURDAY
FULL MOON

17 SUNDAY

A GWR poster by Borlase Smart, promoting rail travel to Cornwall, c.1935.

East Coast Types

No. 3 The Lobsterman

Travel cheaply by L·N·E·R

AUGUST

WEEK 34

18 MONDAY

19 TUESDAY

20 WEDNESDAY

21 THURSDAY

22 FRIDAY

23 SATURDAY
LAST QUARTER

24 SUNDAY

This poster, the third in LNER's poster series of 'East Coast Types' (see weeks 4, 5, 25, 35 and 41) is by Frank Newbould.

AUGUST

WEEK 35

25 MONDAY
Summer Bank Holiday, UK (exc. Scotland)

26 TUESDAY

27 WEDNESDAY

28 THURSDAY

29 FRIDAY

30 SATURDAY
NEW MOON

31 SUNDAY

Another poster in LNER's 'East Coast Types' series (see weeks 4, 5, 25, 34 and 41): 'The Bait Gatherers' by Frank Newbould, 1947.

REDCAR

ILLUSTRATED BOOKLET FREE FROM TOWN CLERK REDCAR
OR ANY L·N·E·R· INQUIRY OFFICE

SEPTEMBER

WEEK 36

1 MONDAY
Holiday, Canada (Labour Day) and USA (Labor Day)

2 TUESDAY
First Day of Ramadân (subject to sighting of the moon)

3 WEDNESDAY

4 THURSDAY

5 FRIDAY

6 SATURDAY

7 SUNDAY
FIRST QUARTER
Father's Day, Australia and New Zealand

An LNER poster by Austin Cooper, 1930.

SEPTEMBER

WEEK 37

8 MONDAY

9 TUESDAY

10 WEDNESDAY

11 THURSDAY

12 FRIDAY

13 SATURDAY

14 SUNDAY

An aerodynamic train speeds across the Royal Border Bridge in Northumberland in this LNER poster. The artist was Tom Purvis, who rallied for the professionalism of commercial art and in 1930 was one of a group of artists who founded the Society of Industrial Artists, which campaigned for improved standards of training for commercial artists. In 1936 he became one of the first Royal Designers for Industry.

"THE CORONATION"
CROSSING THE ROYAL BORDER BRIDGE BERWICK-UPON-TWEED
IT'S QUICKER BY RAIL
FULL INFORMATION FROM ANY L·N·E·R OFFICE OR AGENCY

SEPTEMBER

WEEK 38

15 MONDAY
FULL MOON

16 TUESDAY

17 WEDNESDAY

18 THURSDAY

19 FRIDAY

20 SATURDAY

21 SUNDAY

A poster by Wilton Williams, produced by LNER c.1930 to promote rail travel to Knaresborough, North Yorkshire.

SEPTEMBER

WEEK 39

22 MONDAY
LAST QUARTER
Autumnal Equinox

23 TUESDAY

24 WEDNESDAY

25 THURSDAY

26 FRIDAY

27 SATURDAY

28 SUNDAY

A poster by Leonard Richmond, produced by British Railways (Western Region) to promote travel to Tintern Abbey in Monmouthshire.

TINTERN ABBEY
TRAVEL BY RAIL

BRITISH RAILWAYS
BRITISH RAILWAYS

MAKE THE MOST OF THE AUTUMN DAYS
BEFORE THE LEAVES FALL
TO THE COUNTRY QUICKLY BY SOUTHERN ELECTRIC

SEPTEMBER & OCTOBER

WEEK 40

29 MONDAY
NEW MOON
Michaelmas Day

30 TUESDAY
Jewish New Year (Rosh Hashanah)

1 WEDNESDAY

2 THURSDAY

3 FRIDAY

4 SATURDAY

5 SUNDAY

An SR poster by F.H. Coventry, 1939.

OCTOBER

WEEK 41

6 MONDAY

7 TUESDAY
FIRST QUARTER

8 WEDNESDAY

9 THURSDAY
Jewish Day of Atonement (Yom Kippur)

10 FRIDAY

11 SATURDAY

12 SUNDAY

The first in LNER's poster series of 'East Coast Types' (see weeks 4, 5, 25, 34 and 35), by Frank Newbould, 1931.

East Coast Types

No. 1
The Broads Wherryman

FRANK NEWBOULD

Travel cheaply by L·N·E·R

OCTOBER

WEEK 42

13 MONDAY
Holiday, Canada (Thanksgiving Day)
Holiday, USA (Columbus Day)

14 TUESDAY
FULL MOON
Jewish Festival of Tabernacles (Succoth), First Day

15 WEDNESDAY

16 THURSDAY

17 FRIDAY

18 SATURDAY

19 SUNDAY

An LMS poster by Montague Birrell Black, promoting rail travel to the Welsh seaside town of Colwyn Bay.

OCTOBER

WEEK 43

20 MONDAY

21 TUESDAY
LAST QUARTER
Jewish Festival of Tabernacles (Succoth), Eighth Day

22 WEDNESDAY

23 THURSDAY

24 FRIDAY
United Nations Day

25 SATURDAY

26 SUNDAY
British Summertime ends

This SR poster of 1946 by Leslie Carr promoted the company's new West Country class engines and the return of normal rail services after the Second World War.

FIRST IN THE FIELD

New "WEST COUNTRY" *Engines*

NAMED AFTER TOWNS IN THE WEST OF ENGLAND
LOOK OUT FOR THEM ON THE

SOUTHERN RAILWAY

Getting into its stride again!

HAYBURN WYKE
7 MILES FROM SCARBOROUGH

THE EAST COAST BEAUTY SPOT
ROMANTIC BAY & SCENERY
HOTEL IN BEAUTIFUL GROUNDS

FREQUENT TRAIN SERVICE ON THE SCARBOROUGH AND WHITBY LINE.

OCTOBER & NOVEMBER

WEEK 44

27 MONDAY
Holiday, Republic of Ireland
Holiday, New Zealand (Labour Day)

28 TUESDAY
NEW MOON

29 WEDNESDAY

30 THURSDAY

31 FRIDAY
Hallowe'en

1 SATURDAY
All Saints' Day

2 SUNDAY

A 1920s railway poster by Alice Cole, promoting travel to the Yorkshire coast.

NOVEMBER

WEEK 45

3 MONDAY

4 TUESDAY

5 WEDNESDAY
Guy Fawkes' Day

6 THURSDAY
FIRST QUARTER

7 FRIDAY

8 SATURDAY

9 SUNDAY
Remembrance Sunday, UK

An LNER poster by Tom Purvis, promoting parked railway carriages as affordable holiday camping accommodation.

CAMPING COACHES
IN ENGLAND AND SCOTLAND
ACCOMMODATION FOR SIX PERSONS - £3·3·0 PER WEEK
ASK FOR DETAILS AT ANY L·N·E·R STATION OR OFFICE

THE CALEDONIAN RAILWAY
Through Tickets *via* Balloch

The **Tarbet Hotel**
· LOCH LOMOND ·

MOUNTAINEERING
TROUT and SALMON
FISHING ~ BOATING
GOLFING ~ TENNIS
Splendid Roads for
MOTORING & CYCLING

Principal Hotel on the Loch ~ in the
Centre of the Grandest Highland Scenery

NOVEMBER

WEEK 46

10 MONDAY

11 TUESDAY
Holiday, Canada (Remembrance Day)
and USA (Veterans' Day)

12 WEDNESDAY

13 THURSDAY
FULL MOON

14 FRIDAY

15 SATURDAY

16 SUNDAY

A Caledonian Railway poster by 'DNA', 1920.

NOVEMBER

WEEK 47

17 MONDAY

18 TUESDAY

19 WEDNESDAY
LAST QUARTER

20 THURSDAY

21 FRIDAY

22 SATURDAY

23 SUNDAY

Walter E. Spradbery painted this view of the South Downs for an SR poster in the 1930s.

LNER WESTERN HIGHLANDS LMS
IT'S QUICKER BY RAIL
FULL INFORMATION FROM LNER AND LMS OFFICES AND AGENCIES

NOVEMBER

WEEK 48

24 MONDAY

25 TUESDAY

26 WEDNESDAY

27 THURSDAY
FULL MOON
Holiday, USA (Thanksgiving Day)

28 FRIDAY

29 SATURDAY

30 SUNDAY
Advent Sunday
St Andrew's Day

A poster by Arthur J. Burgess, produced jointly by LNER and LMS in 1935.

DECEMBER

WEEK 49

1 MONDAY

2 TUESDAY

3 WEDNESDAY

4 THURSDAY

5 FRIDAY
FIRST QUARTER

6 SATURDAY

7 SUNDAY

LMS produced this poster by S. J. Lamorna Birch in 1924 to advertise its service to Buxton in Derbyshire.

BUXTON
THE MOUNTAIN SPA
BY S.J. LAMORNA BIRCH. R.W.S.

LMS

DECEMBER

WEEK 50

8 MONDAY

9 TUESDAY

10 WEDNESDAY

11 THURSDAY

12 FRIDAY
FULL MOON

13 SATURDAY

14 SUNDAY

D.Y. Cameron painted this view of the Western Highlands for an LMS poster produced in 1935 to promote rail travel to the area.

DECEMBER

WEEK 51

15 MONDAY

16 TUESDAY

17 WEDNESDAY

18 THURSDAY

19 FRIDAY
LAST QUARTER

20 SATURDAY

21 SUNDAY
Winter Solstice

LNER produced this poster in 1938 as part of a series promoting the company's services to industries in the north-east of England. The artist was Frank Henry Mason.

EAST COAST INDUSTRIES
SERVED BY THE L·N·E·R

DECEMBER

WEEK 52

22 MONDAY
Jewish Festival of Chanukah, First Day

23 TUESDAY

24 WEDNESDAY
Christmas Eve

25 THURSDAY
Christmas Day
Holiday, UK, Republic of Ireland,
Canada, USA, Australia and New Zealand

26 FRIDAY
Boxing Day (St Stephen's Day)
Holiday, UK, Republic of Ireland,
Canada, Australia and New Zealand

27 SATURDAY
NEW MOON

28 SUNDAY

An LNER poster by Van Jones, showing the Northumberland town of Berwick-upon-Tweed, 1941.

DECEMBER & JANUARY

WEEK 1, 2009

29 MONDAY
Islamic New Year (subject to sighting of the moon)

30 TUESDAY

31 WEDNESDAY
New Year's Eve

1 THURSDAY
New Year's Day
Holiday, UK, Republic of Ireland,
Canada, USA, Australia and New Zealand

2 FRIDAY
Holiday, Scotland and New Zealand

3 SATURDAY

4 SUNDAY
FIRST QUARTER

A 1950s British Railways poster by Reginald Mayes, promoting the Queen of Scots Pullman service from King's Cross, London, to Queen Street, Glasgow each weekday.

NOTES